Biscuit for Your Thoughts?

PHILOSOPHY ACCORDING TO DOGS

Published in the United States by
ULYSSES PRESS
P.O. Box 3440
Berkeley, CA 94703
www.ulyssespress.com

ISBN13: 978-1-61243-357-8
Library of Congress Catalog Number: 2014932262

Printed in the United States by Bang Printing

10 9 8 7 6 5 4 3 2 1

Acquisitions: Keith Riegert
Managing Editor: Claire Chun
Proofreader: Renee Rutledge
Cover design: Keith Riegert
Interior design: Jake Flaherty

Distributed by Publishers Group West

Biscuit for Your Thoughts?
PHILOSOPHY ACCORDING TO DOGS

PHOTOGRAPHS BY ANDREW DARLOW

Ulysses Press

Three things cannot remain hidden long: the sun, the moon and the squeaky.

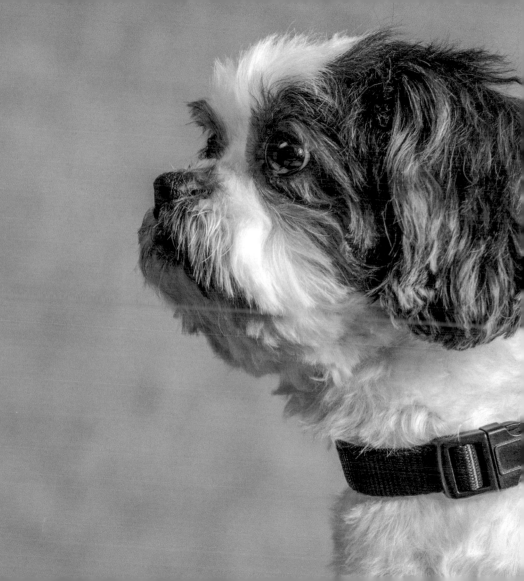

If life closes a door,
bark until someone
opens it again.

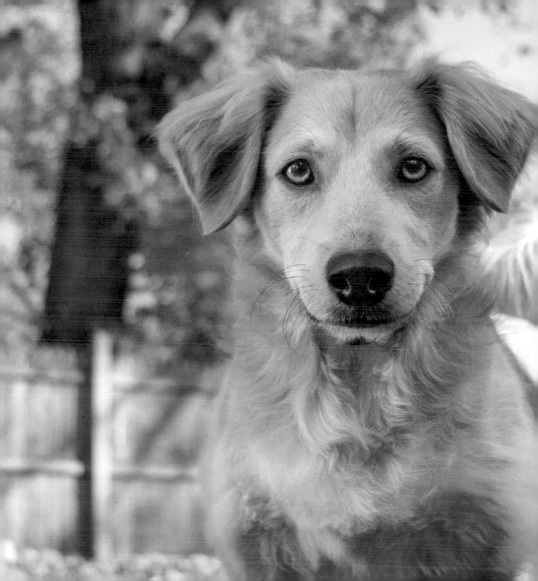

Sometimes the reward is in the last place you'd look.

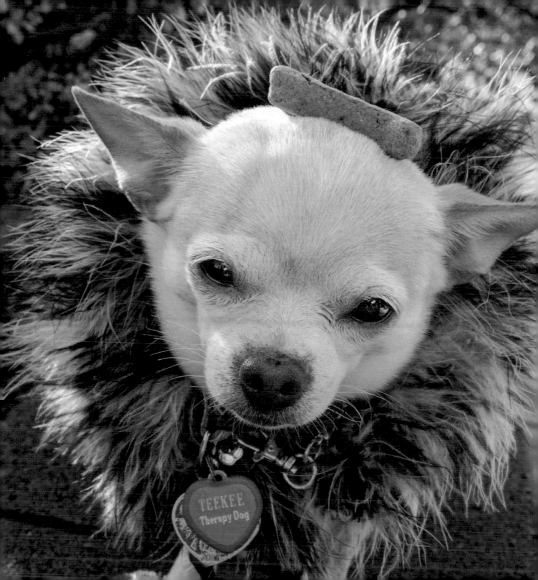

LIVE LIFE
OFF THE LEASH.

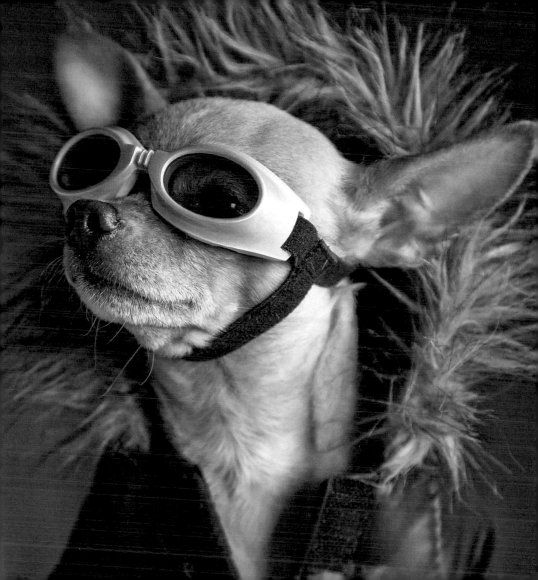

*Beauty is in the eye
of the treat-holder.*

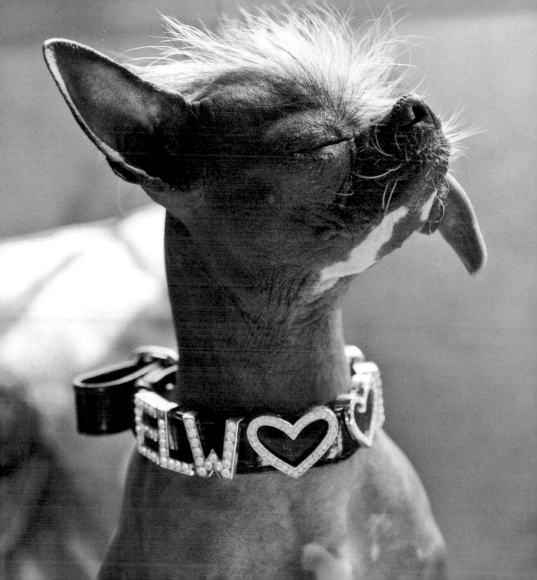

Absence makes the heart grow fonder and the slippers grow tastier.

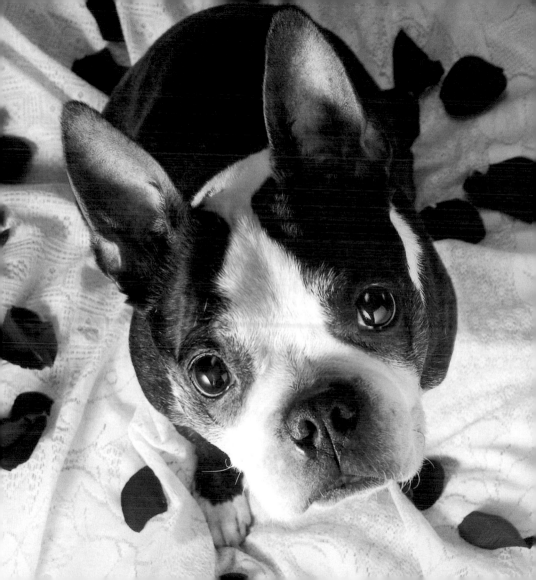

If the tutu fits,
wear it.

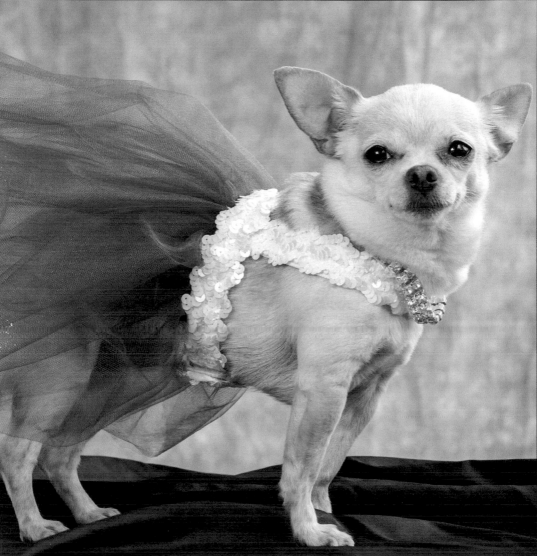

Take all your wrinkles
as laugh lines.

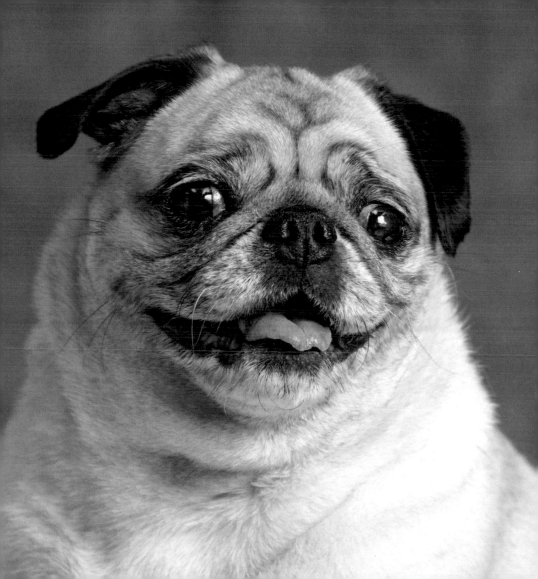

Live life on the edge
(and nap there too).

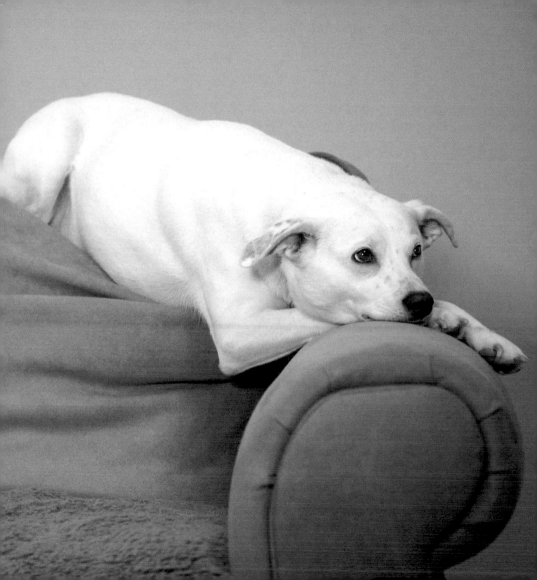

PLAY HARD,
BARK HARDER.

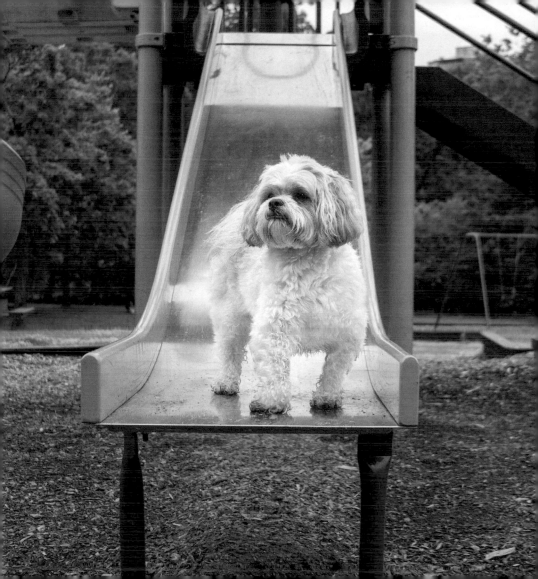

From time to time, it's okay to wake up on the wrong side of the floor.

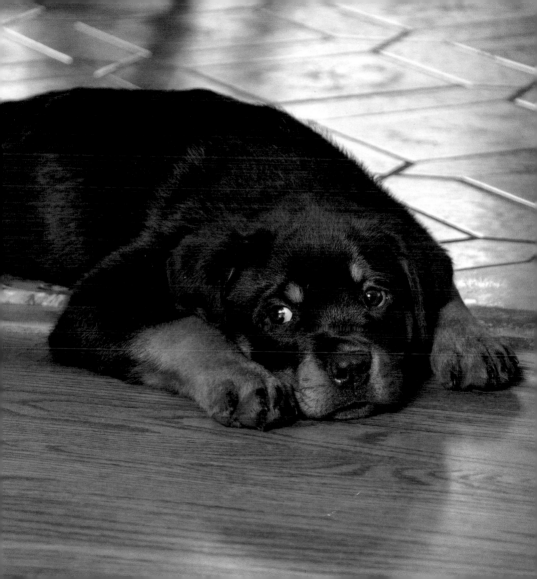

There's no accounting for
a man's taste in socks.

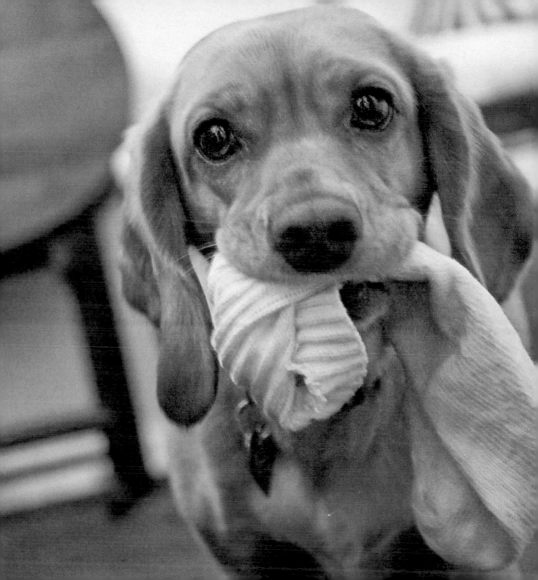

It's not where you're going,

it's how you get there.

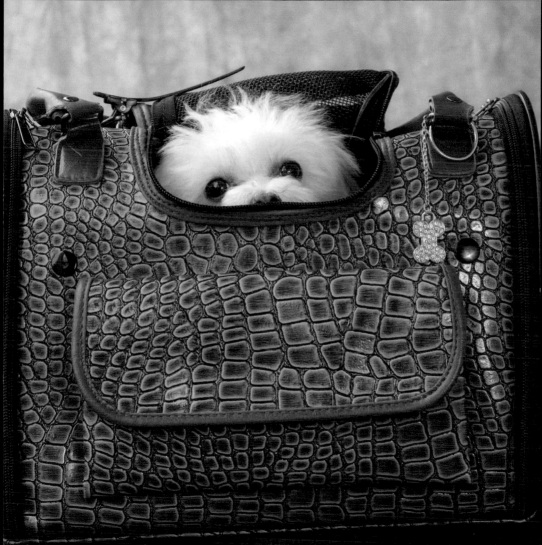

Every dog has his day.
Have yours at the beach.

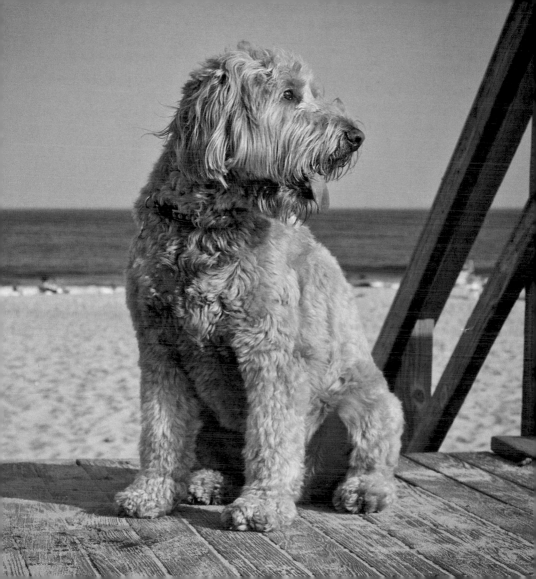

Aristotle's dog once said, "What is a friend? A single soul dwelling in two bodies."

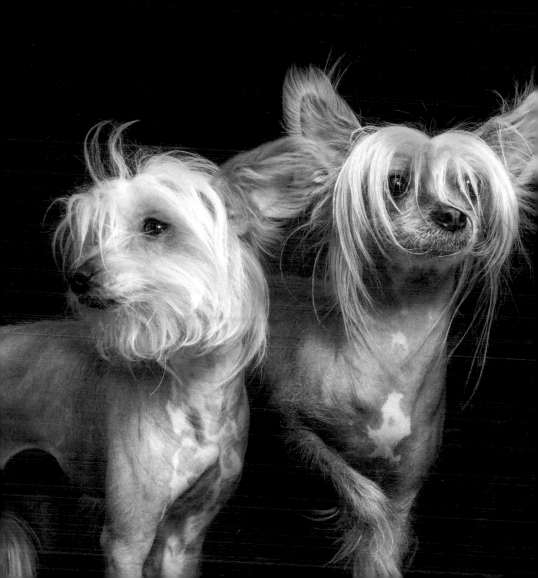

Forget the catwalk, strut your stuff on the dog walk.

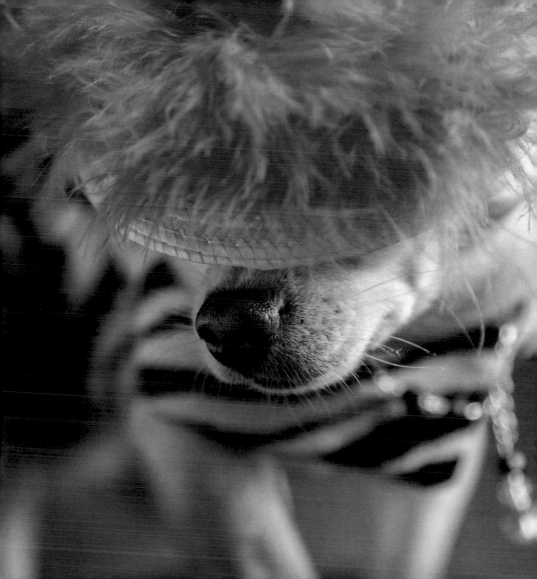

Everybody could use
a helping head from
time to time.

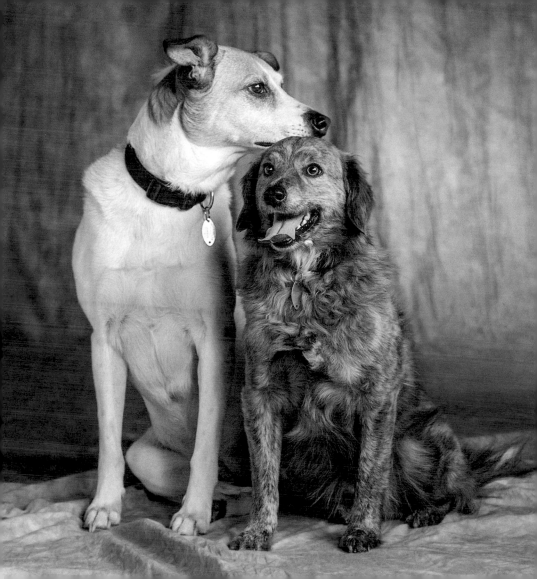

All it takes to be
a philosopher is a
sense of wonder.

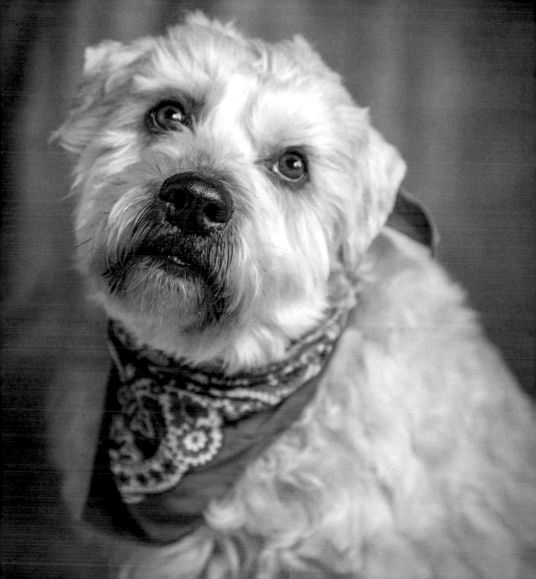

*Take the time each day
to look up and ponder
the clouds and the stars
and the Frisbee.*

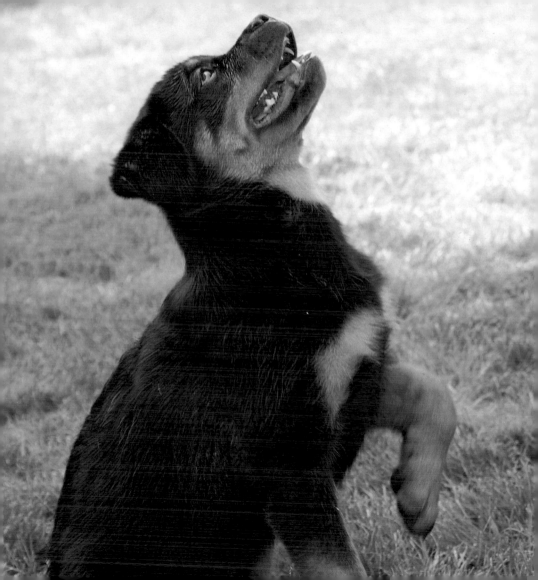

CLASH BRILLIANTLY.

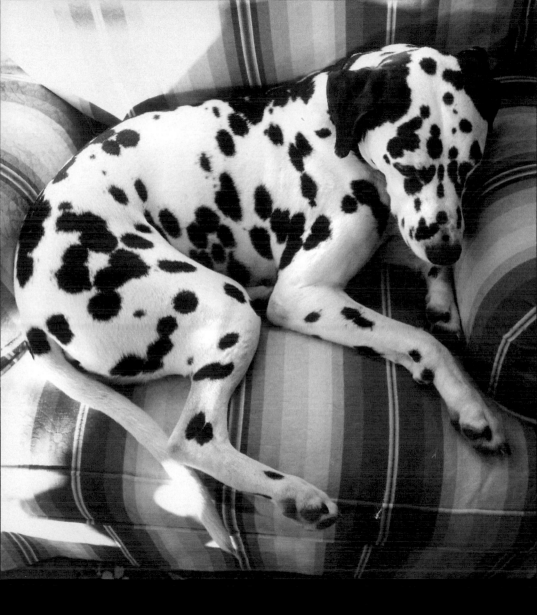

One floppy ear is no
excuse to half listen.

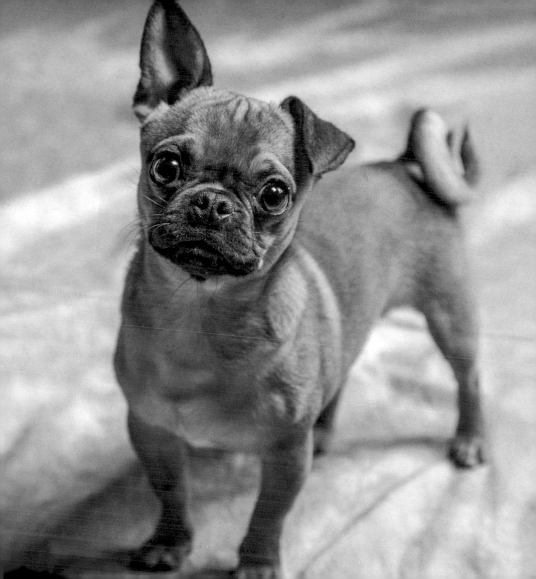

Be who you are and bark what you feel, because those who mind don't matter and those who matter don't mind.

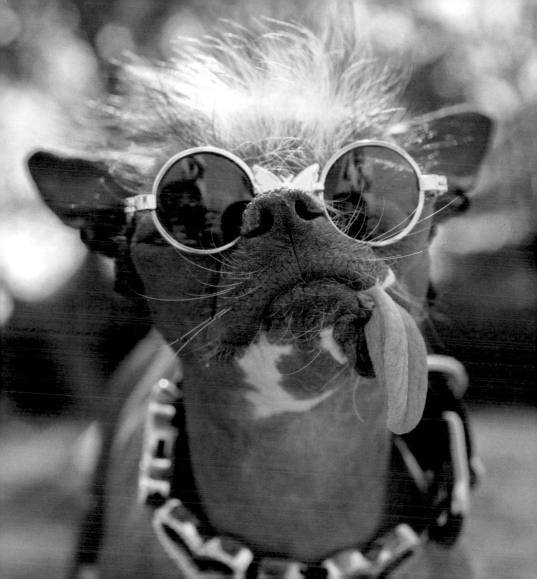

Dress too sexy for
your leash.

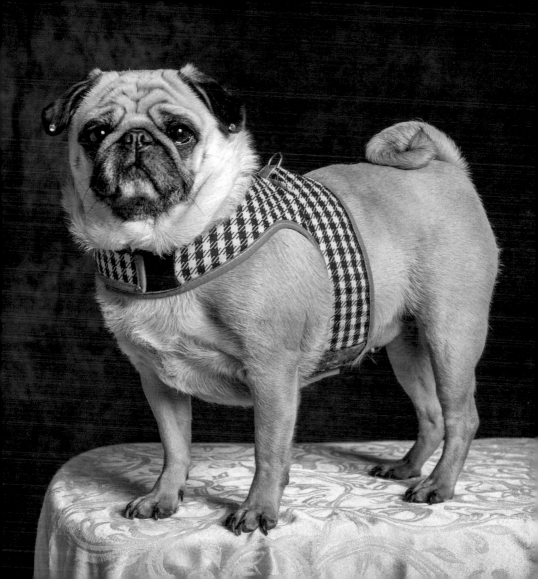

Never lose the ability to be amazed.

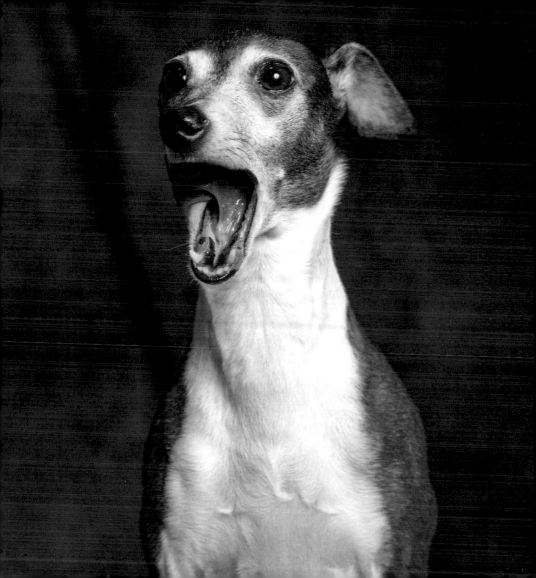

Savor the world.

Lick everything.

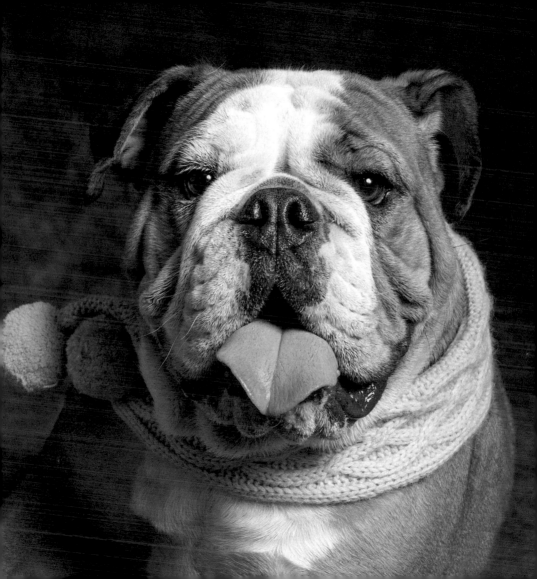

Never trust mailmen,
groomers or
vacuum cleaners.

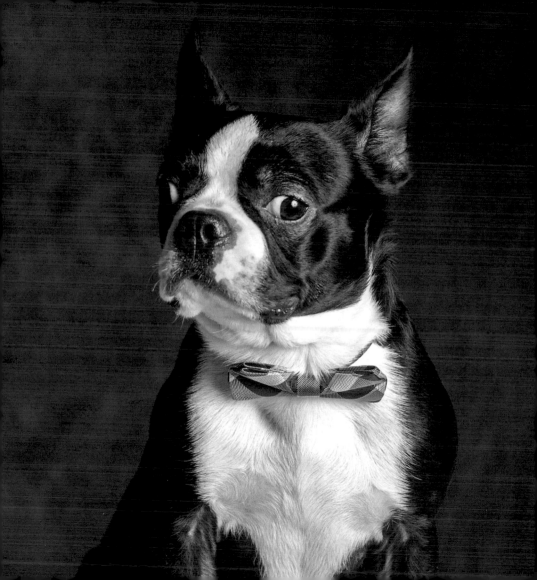

Nobody will ever know you as well as your brother or sister, a friend gifted from birth.

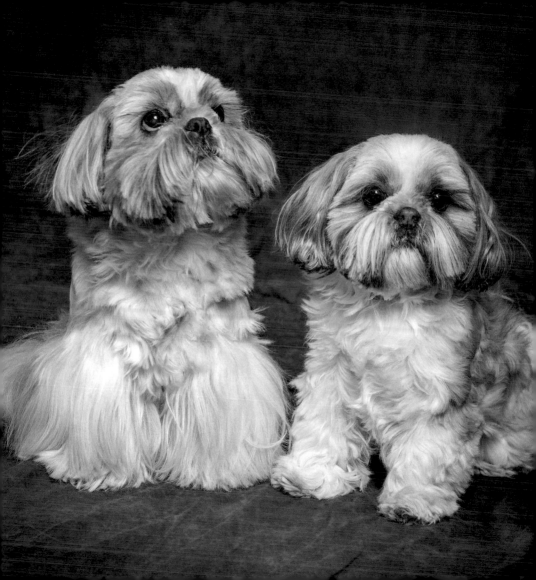

There's no predicting what you'll want to wear later in life.

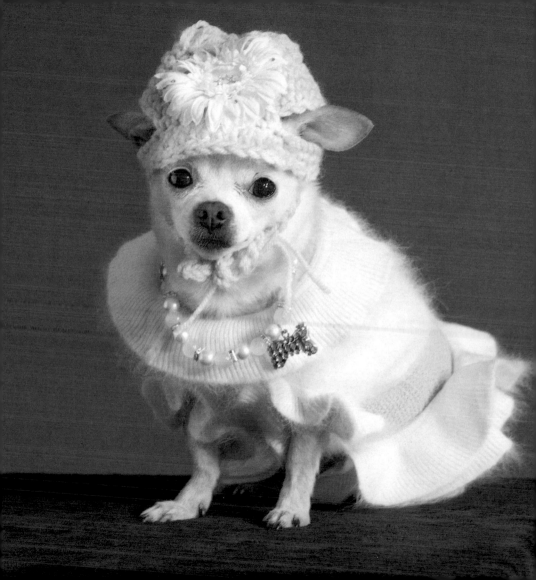

Make at least one
remarkably different
friend in your life.

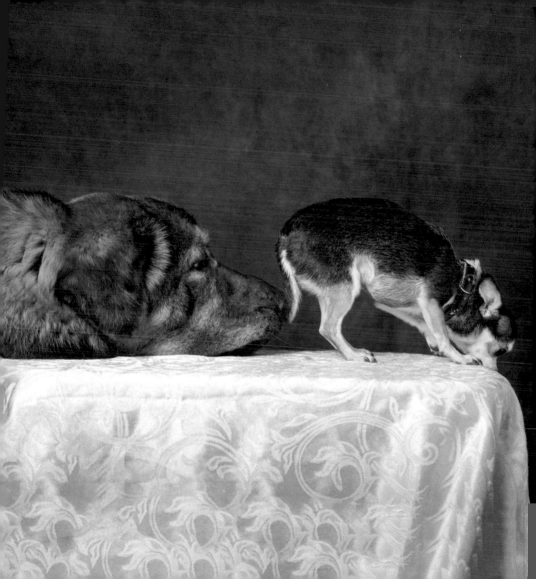

Let sleeping dogs lie.

And lie.

And lie.

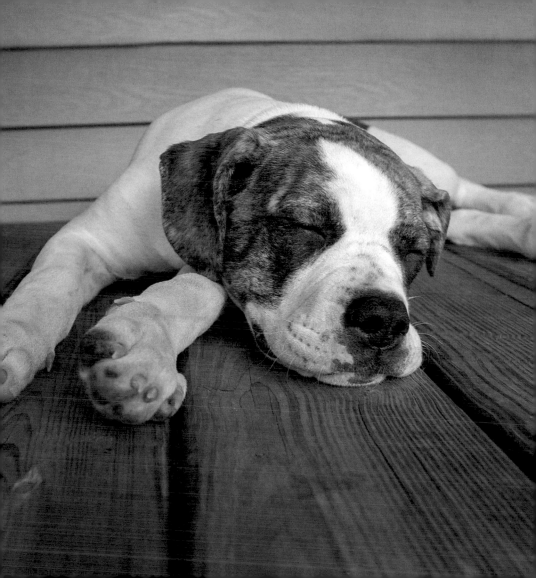

Any bad day can be made better with a great hat.

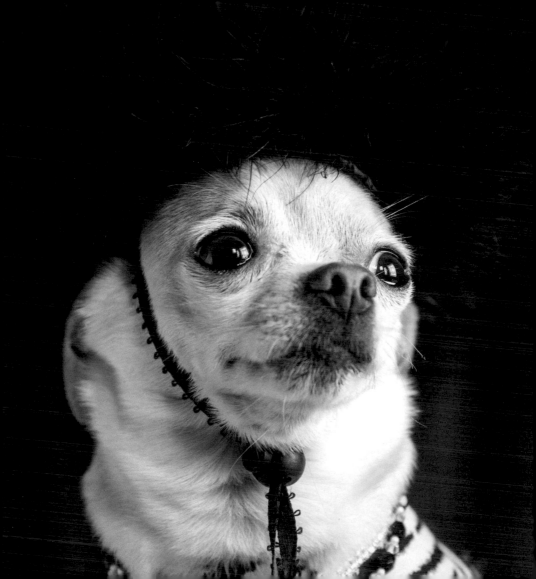

It takes a good dog to
be a great listener.

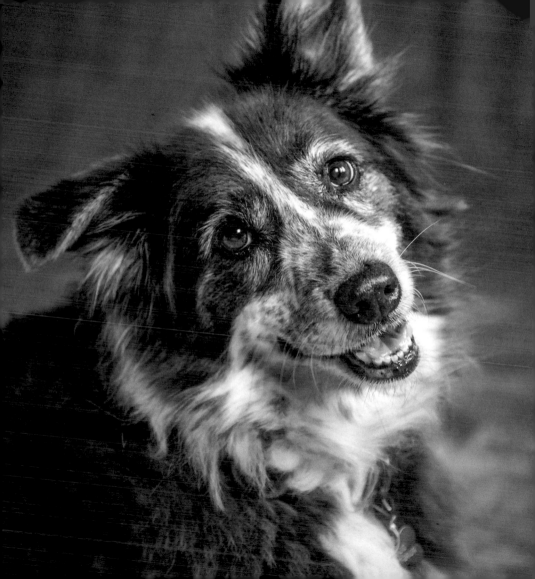

It's never too late to take

the trip of a lifetime.

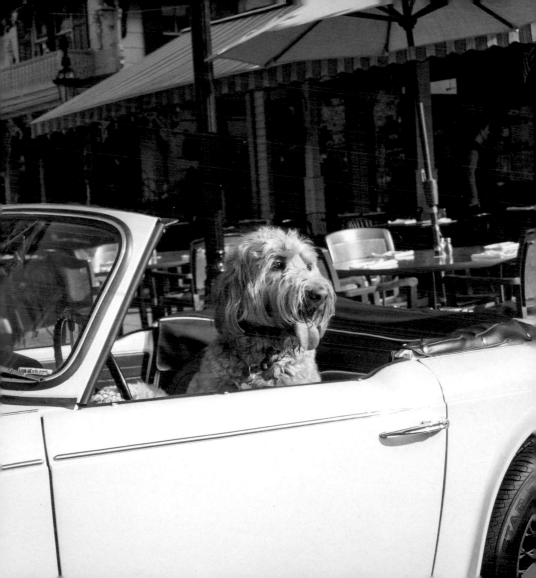

You never know when you may meet your new best friend, so keep staring out the window.

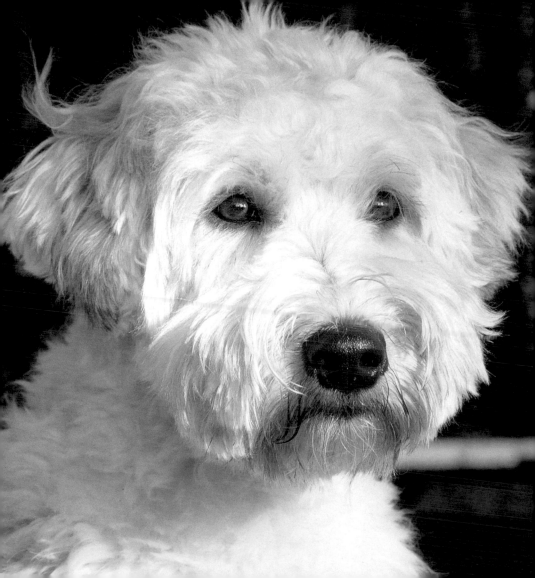

Pursue your dreams
as diligently as you
would pursue that
elusive UPS truck.

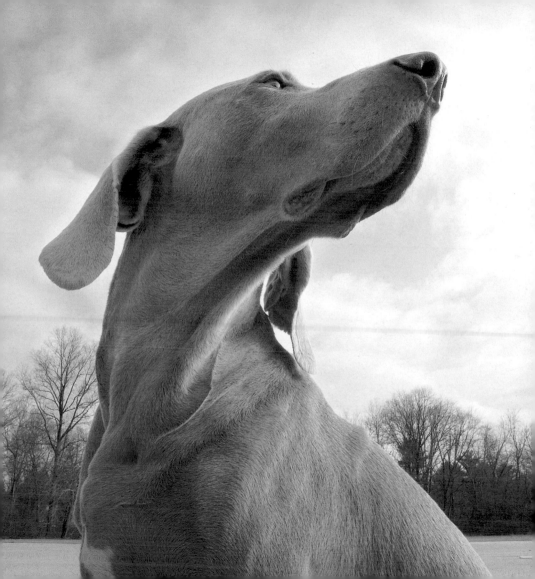

Home is where the dog is.

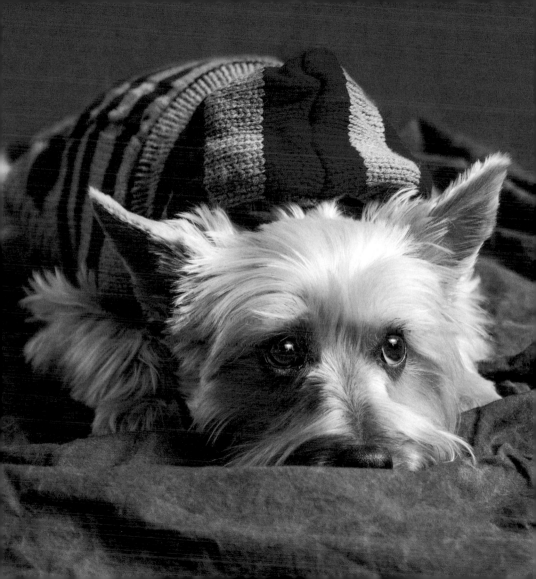

Falling in love is like getting off the couch. You close your eyes and jump.

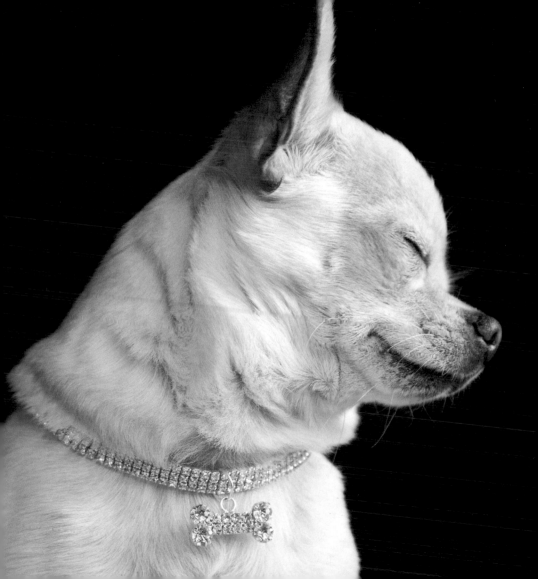

The food is always better

off someone else's plate.

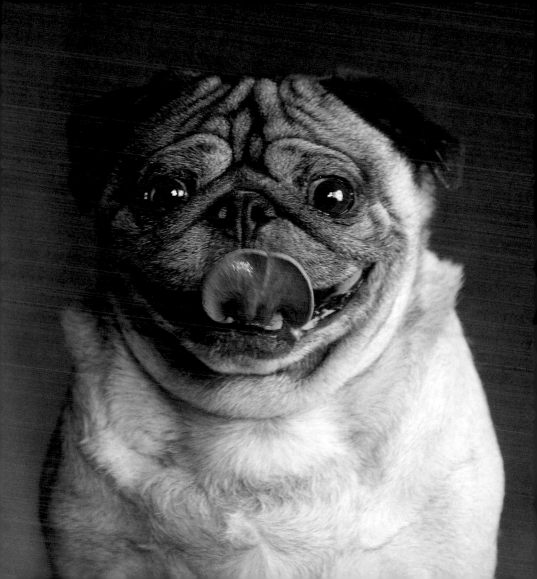

The best holiday parties end waking up at 2:00 p.m. The next day. In a sleigh. Dressed as an elf.

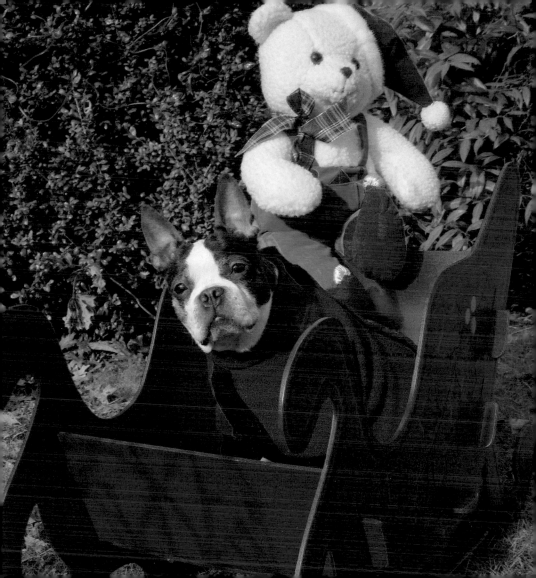

Accidentally wearing the same outfit as everyone else is not the end of the world.

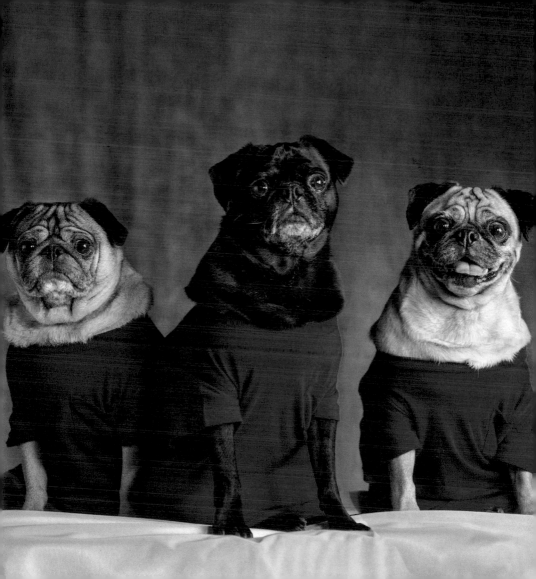

Unconditional love is the greatest source of courage and strength.

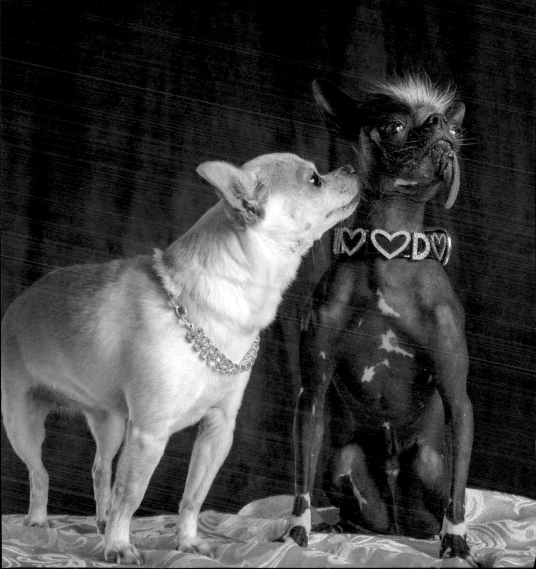

You don't need the body
of an athlete to run free.

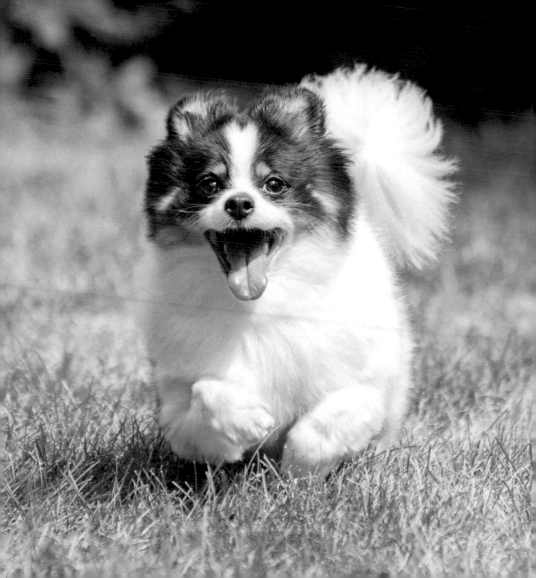

Everyone makes mistakes. It's the big dog that knows when to admit it.

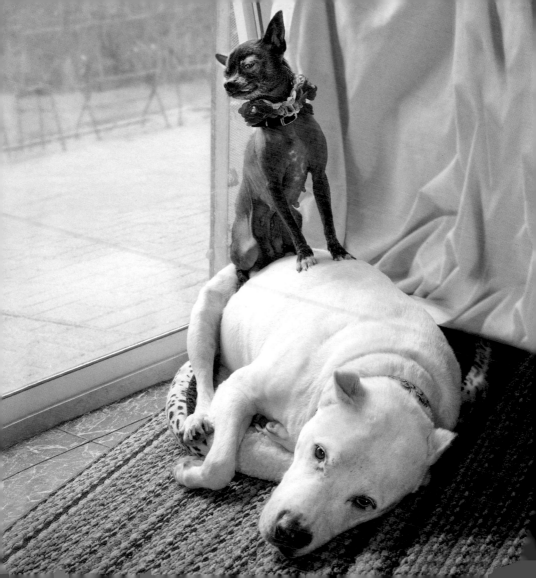

Seize this day as you attacked the unattended ham of your dreams.

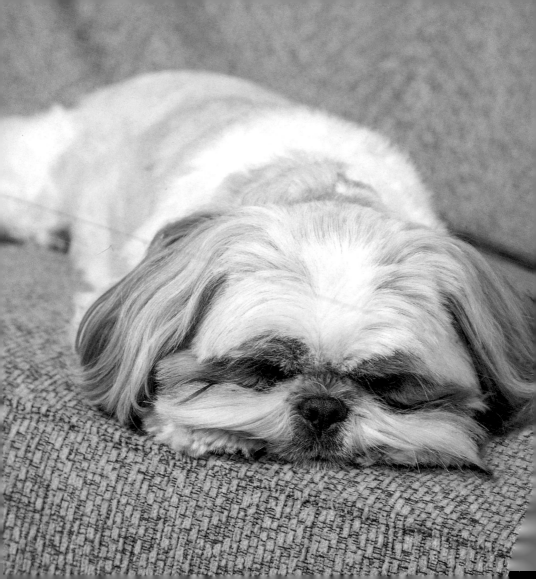

Happiness, my ball
stuck atop the highest shelf
Come down, happiness.

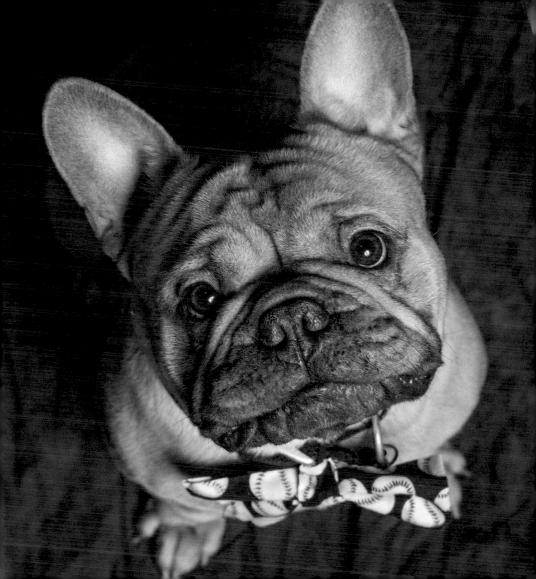

THANK YOU!

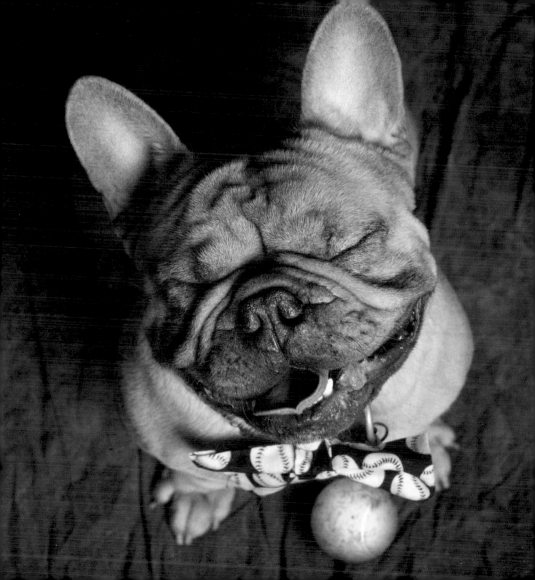

About the Photographer

Andrew Darlow is an award-winning photographer, author and consultant based in New Jersey. His dog and cat photographs have been featured internationally in numerous print and online publications and he is the author of the book *Pet Photography 101: Tips for Taking Better Photos of Your Dog or Cat*. He specializes in capturing the special, and often philosophical, bonds between pets and the people they keep around. To see more of his work, visit CandidCanine.com.

About the Editor

Toast has his Dogtorate of Philosophy from the Oxford Training School & Grooming Salon. He enjoys long walks, organic, fair trade dog treats and sitting on the *New York Times* Sunday crossword puzzle. This is his first book.